STILL TIME

SALLY MANN

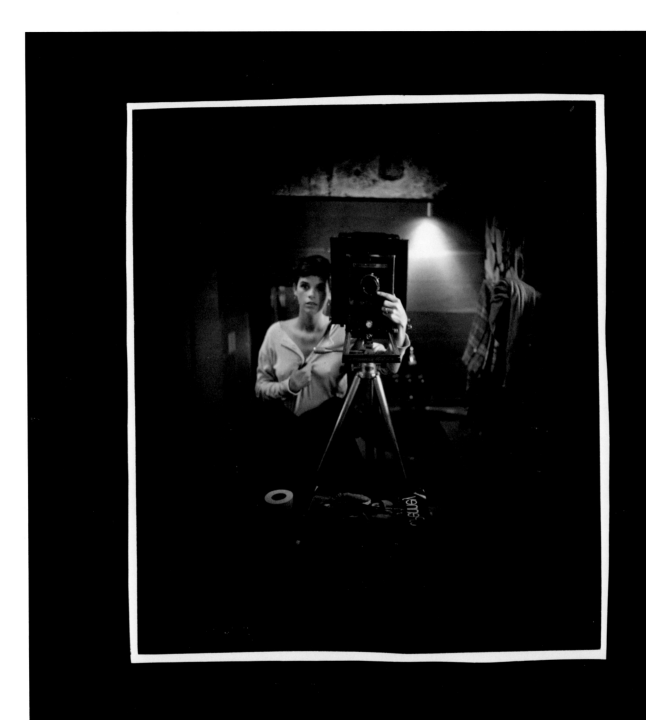

1974

STILL TIME

SALLY MANN

APERTURE

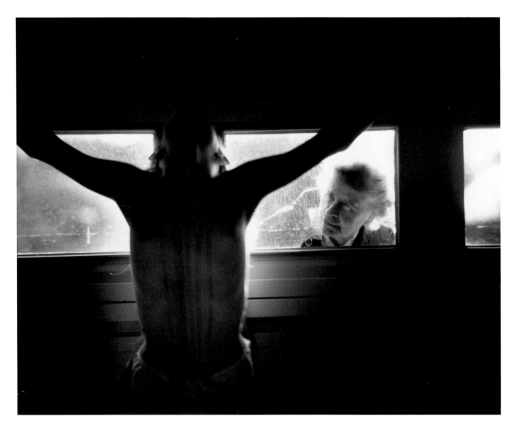

For my mother, Elizabeth E. Munger,
with love and appreciation.

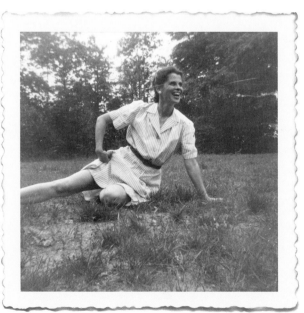

CHILDHOOD HOUSE *(an excerpt)*

. . . Somehow I had assumed
that the past stood still, in perfected effigies of itself,
and that what we had once possessed remained our possession
forever, and that at least the past, our past, our child-
hood, waited, always available, at the touch of a nerve,
did not deteriorate like the untended house of an
aging mother, but stood in pristine perfection, as in
our remembrance. I see that this isn't so, that
memory decays like the rest, is unstable in its essence,
flits, occludes, is variable, sidesteps, bleeds away, eludes
all recovery; worse, is not what it seemed once, alters
unfairly, is not the intact garden we remember but,
instead, speeds away from us backward terrifically
until when we pause to touch that sun-remembered
wall the stones are friable, crack and sift down,
and we could cry at the fierceness of that velocity
if our astonished eyes had time.

—ERIC ORMSBY

Still Time was originally published in 1988 as a small catalogue for an exhibition of the same title. The exhibition was curated by Bari Ballou for the Allegheny Highlands Arts and Crafts Center in Clifton Forge, Virginia. Ms. Ballou secured funding for the project primarily from the Virginia Commission for the Arts.

After leaving Clifton Forge, *Still Time* circulated throughout the state of Virginia under the aegis of the TEAMS program, a service of The Virginia Museum of Fine Arts.

In 1993, *Still Time* was returned to me. That original catalogue and show have been expanded into this present form which now includes some unpublished early work as well as more recent images.

Several people have been particularly helpful to me. Foremost among them are Lorelei Stewart and Anna Gaskell, whose good judgement and humor were invaluable. Betsy Schneider, Jenni Holder, Michel Karmon, Alison Nordstrom and Niall MacKenzie each contributed their expertise.

I appreciate the support I receive from Aperture, and particularly from Melissa Harris, Michael Sand, Michael Hoffman and Roger Straus. Polaroid and Agfa contributed the film for many of the color images.

I continue to be grateful to the John Simon Guggenheim Foundation, the Southeastern Center for Contemporary Art, the Winston Foundation, and the National Endowment for the Arts.

Above all, to my family, Larry, Emmett, Jessie and Virginia, I express my gratitude and love.

From

THE DREAM SEQUENCE

1971

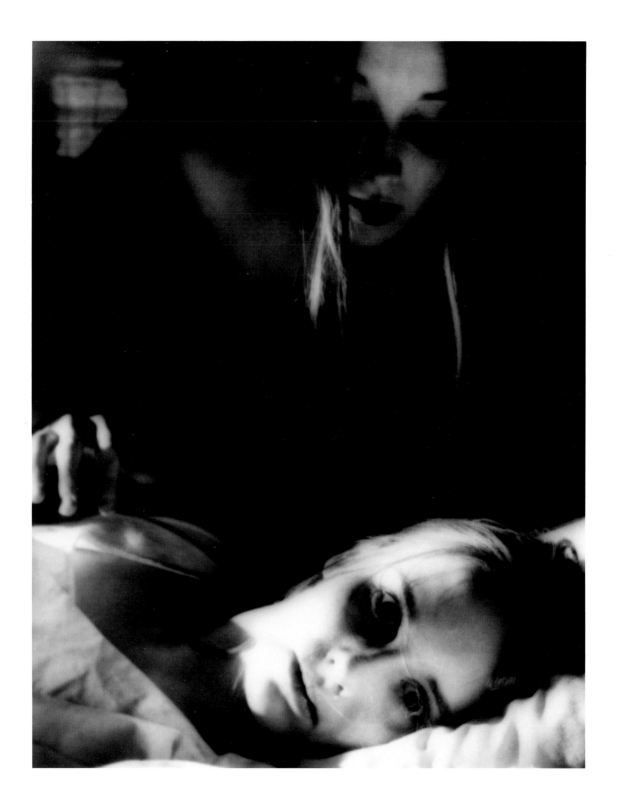

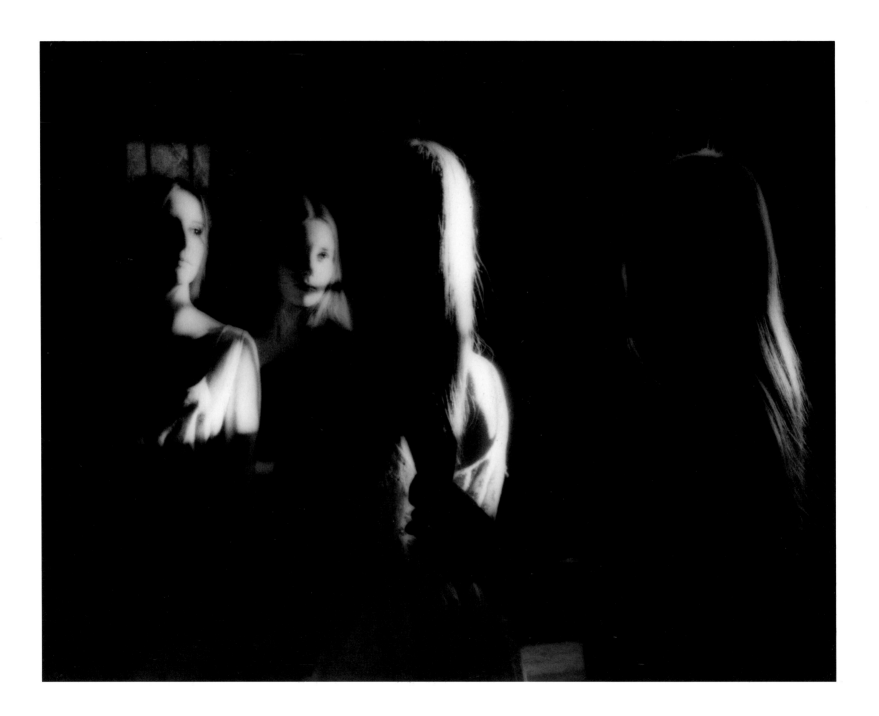

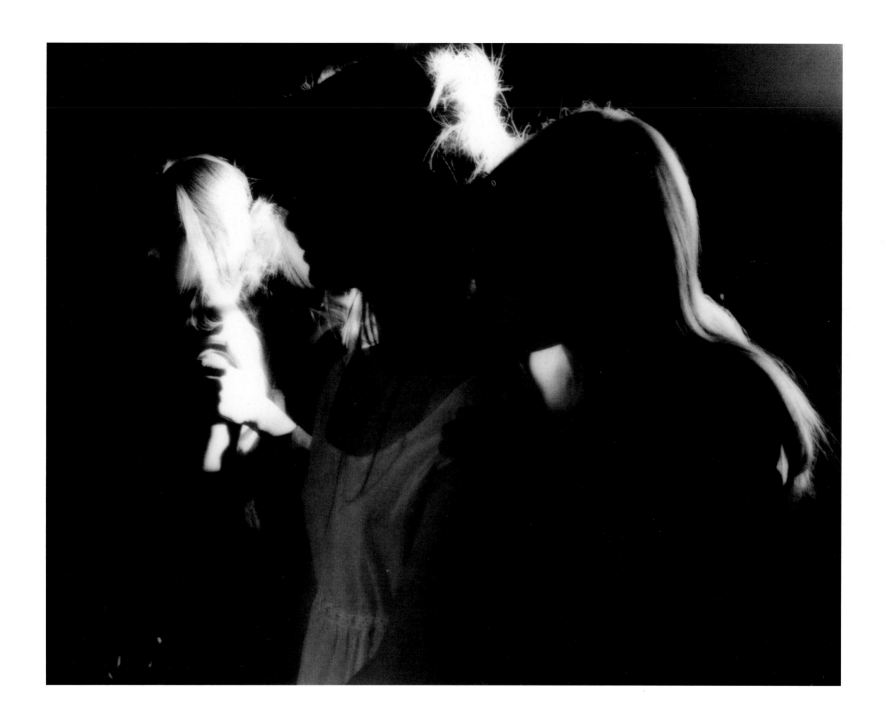

11

LANDSCAPES

1972–1973

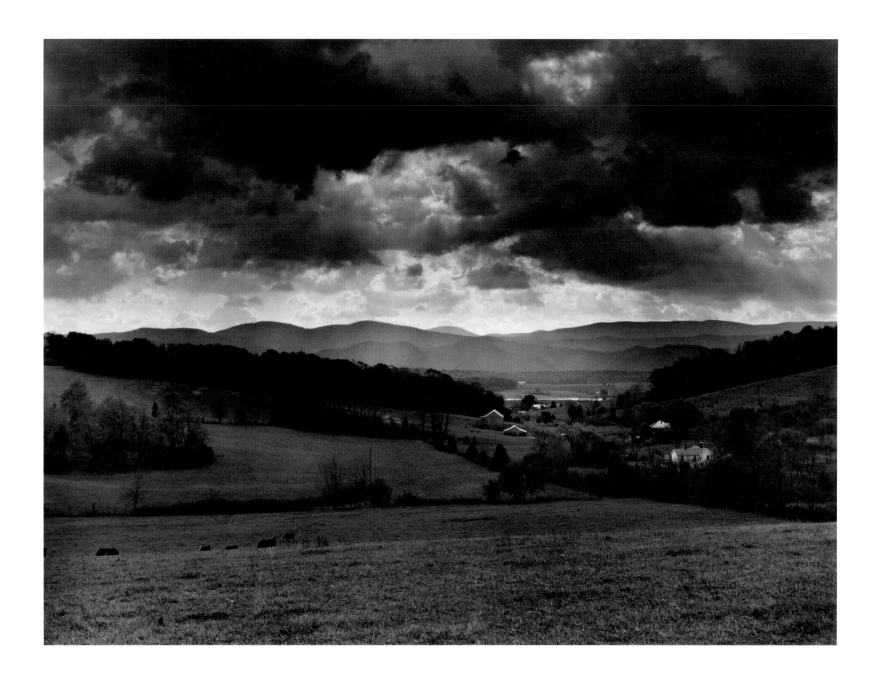

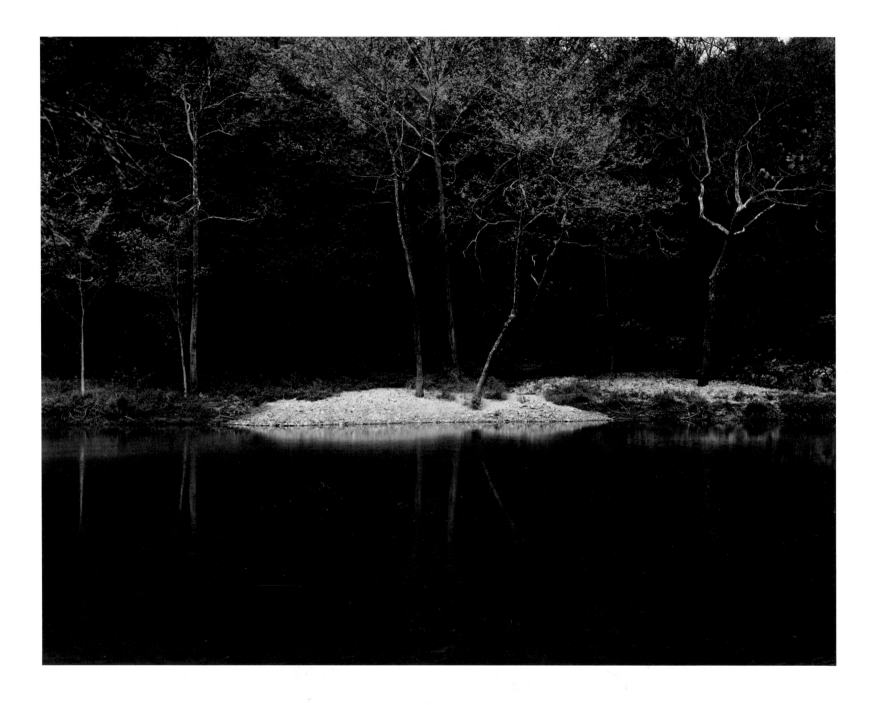

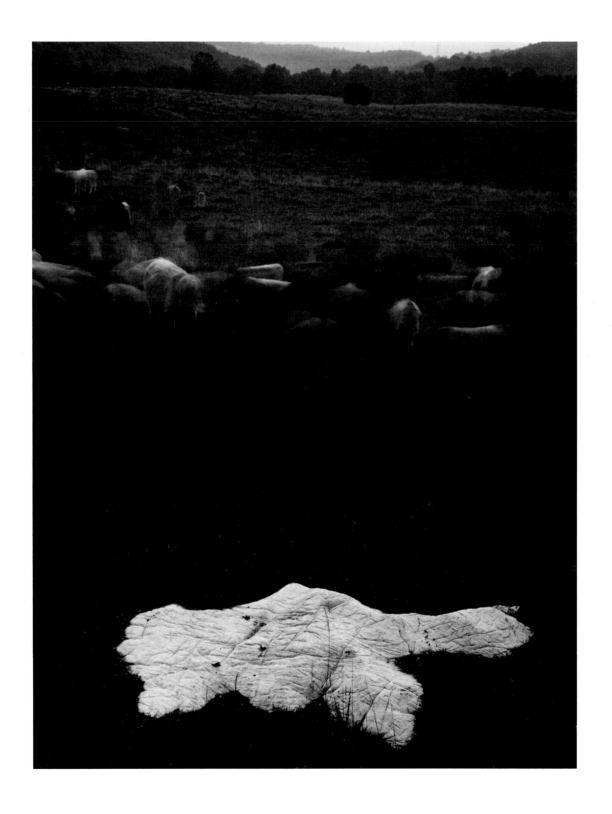

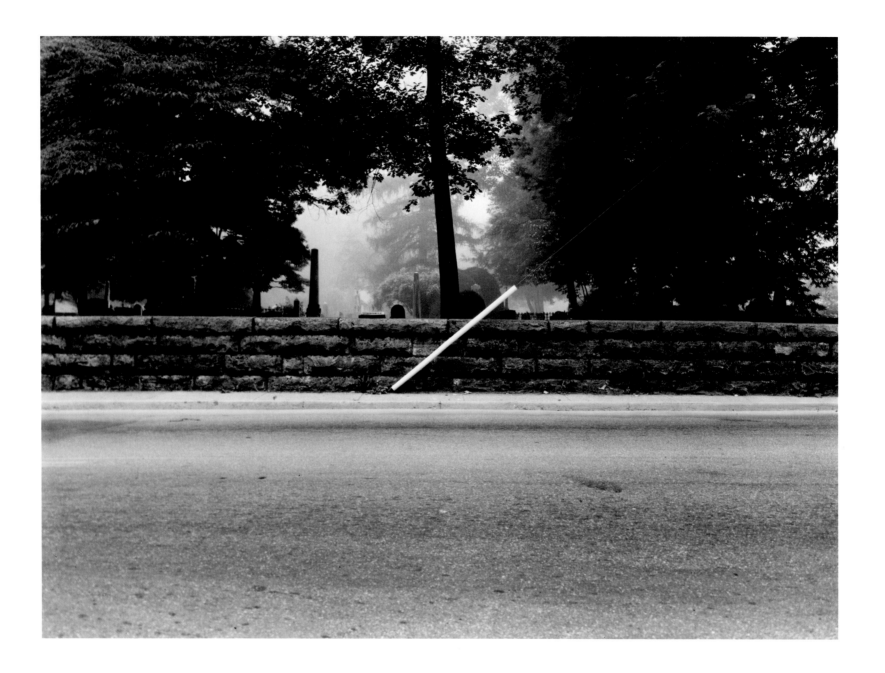

LANDSCAPES

1973–1974

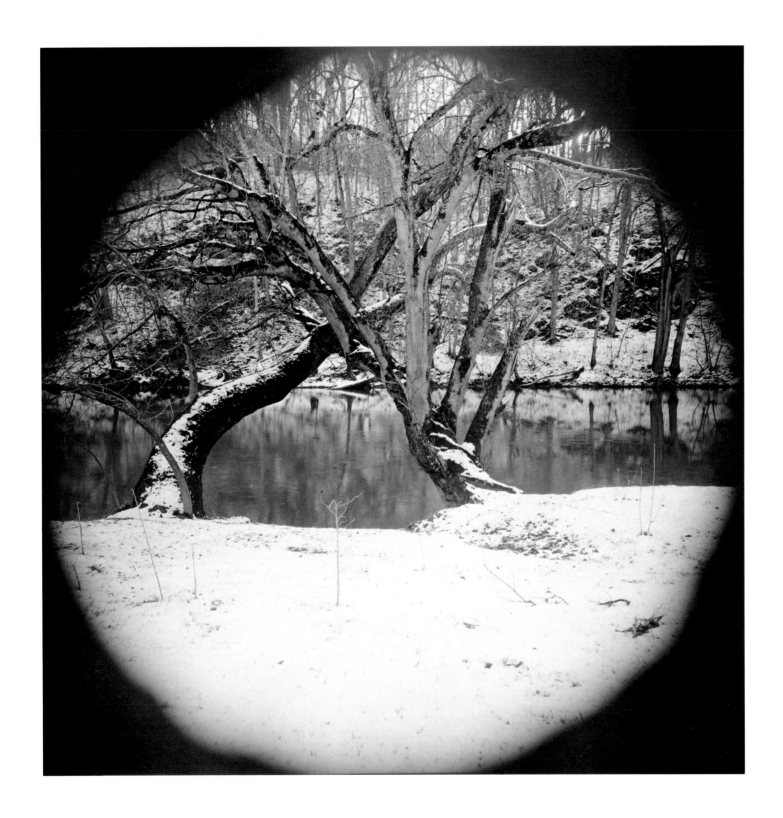

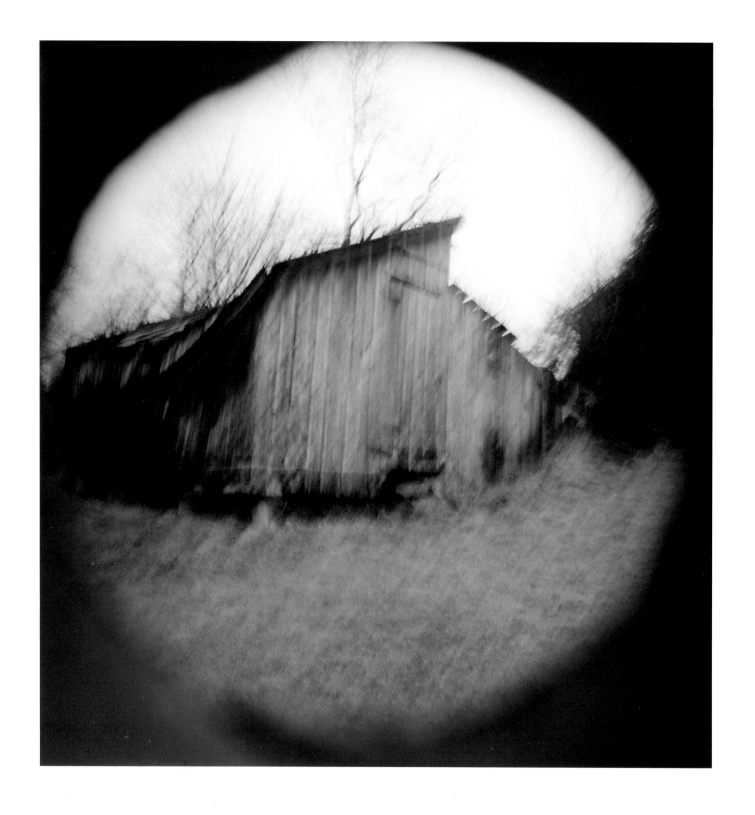

20

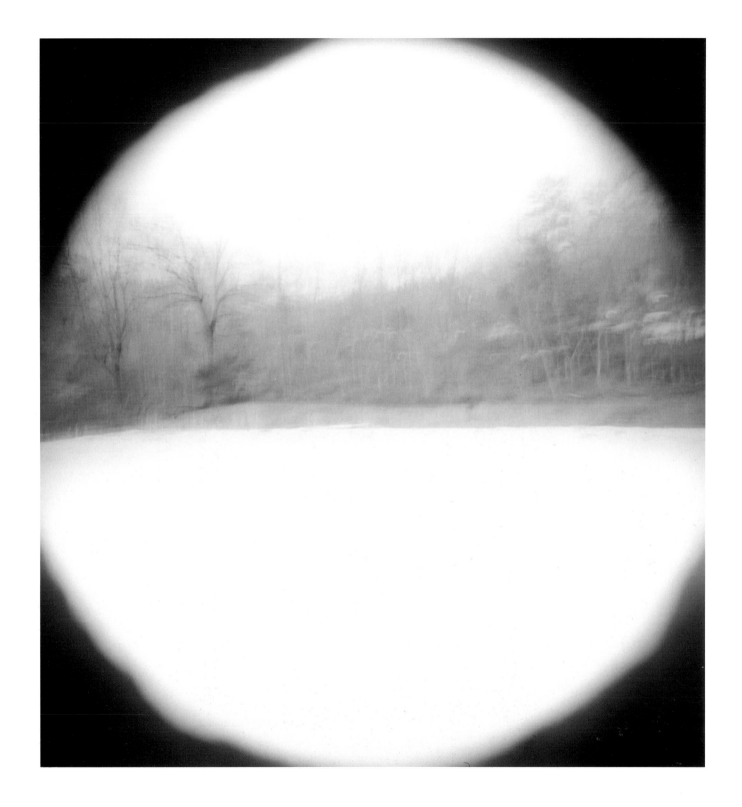

21

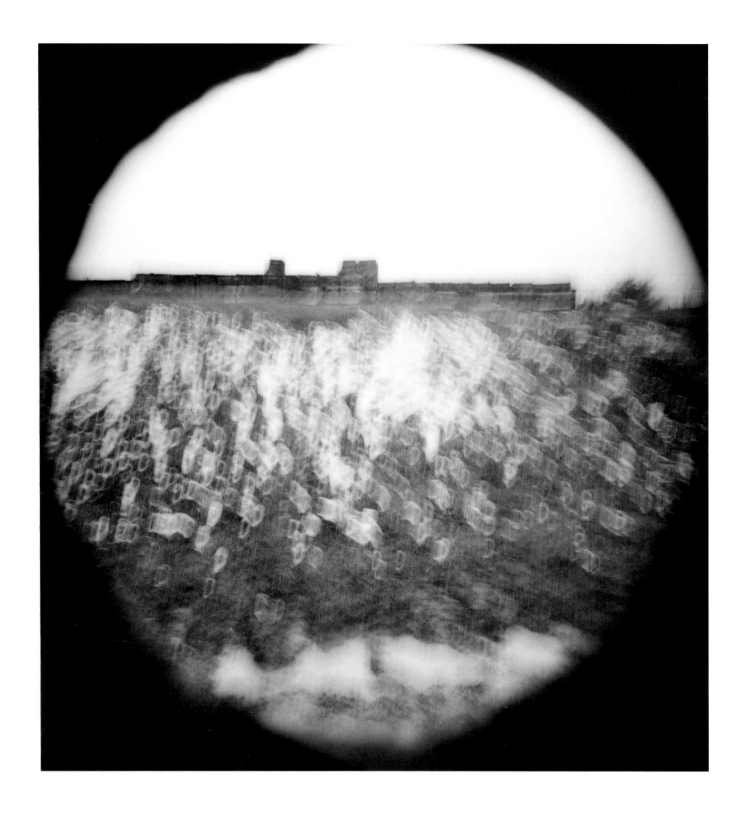

From

THE LEWIS LAW PORTFOLIO

1974–1976

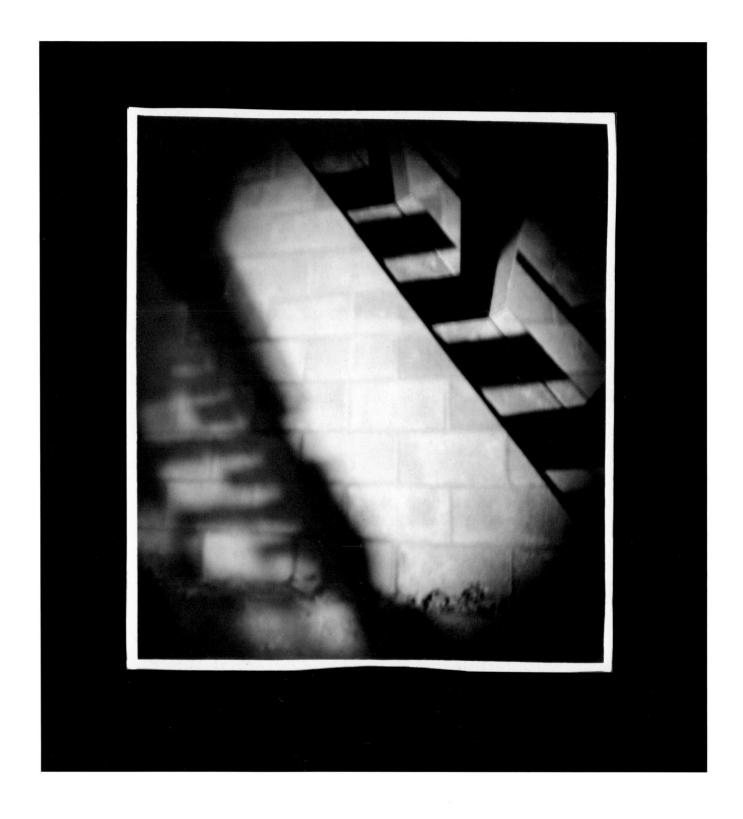

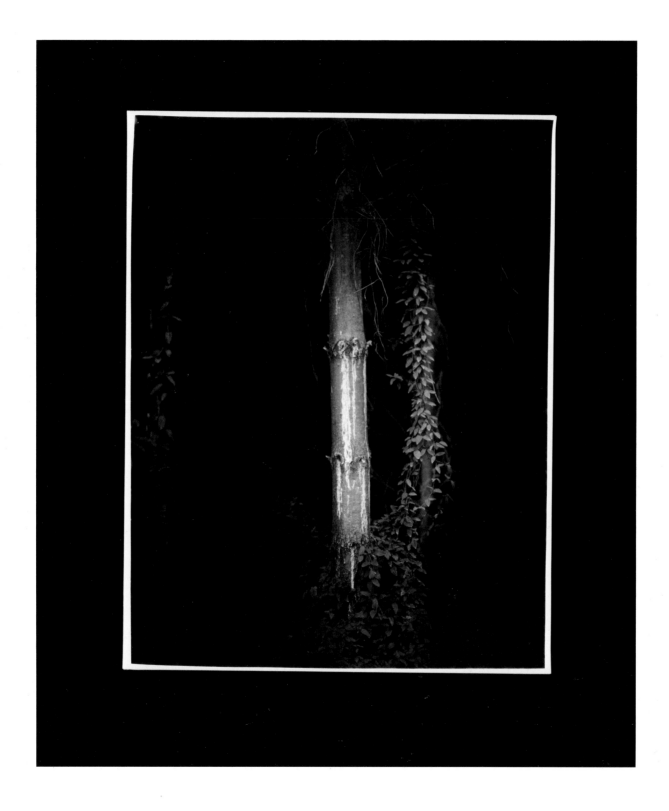

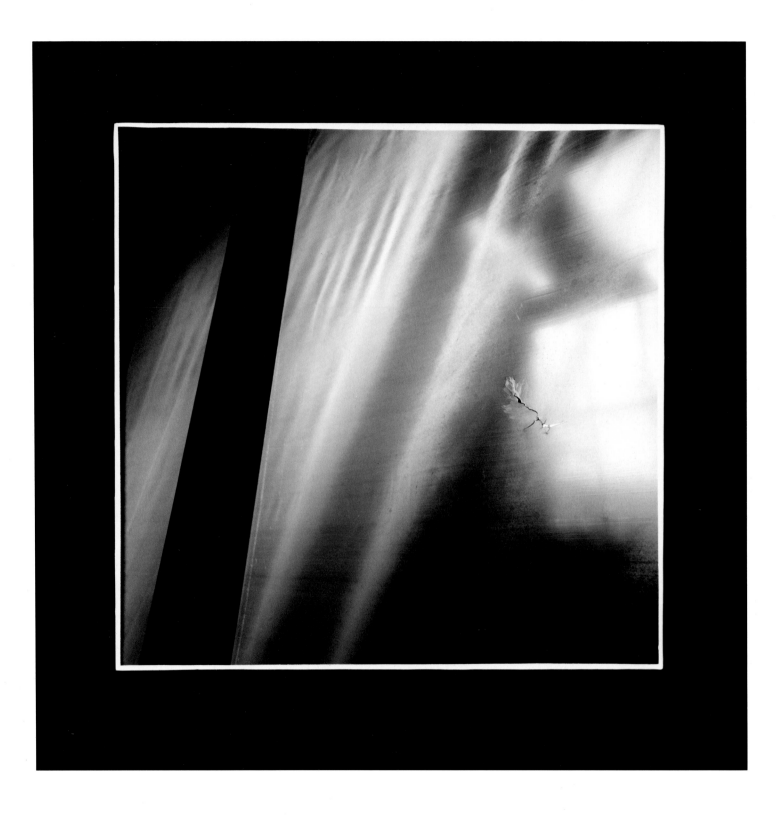

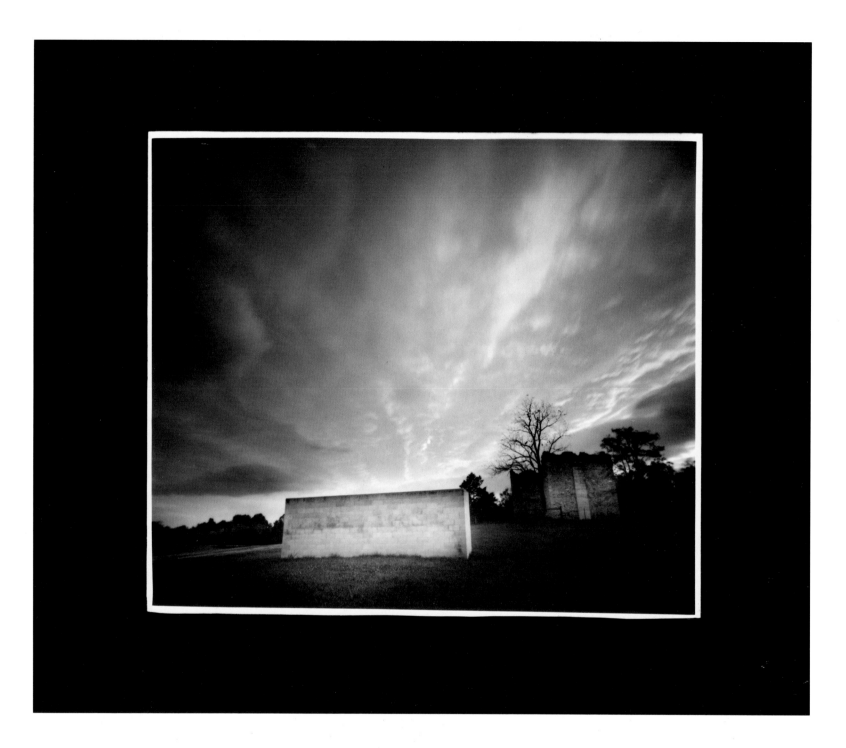

27

PORTRAITS OF WOMEN

1976–1977

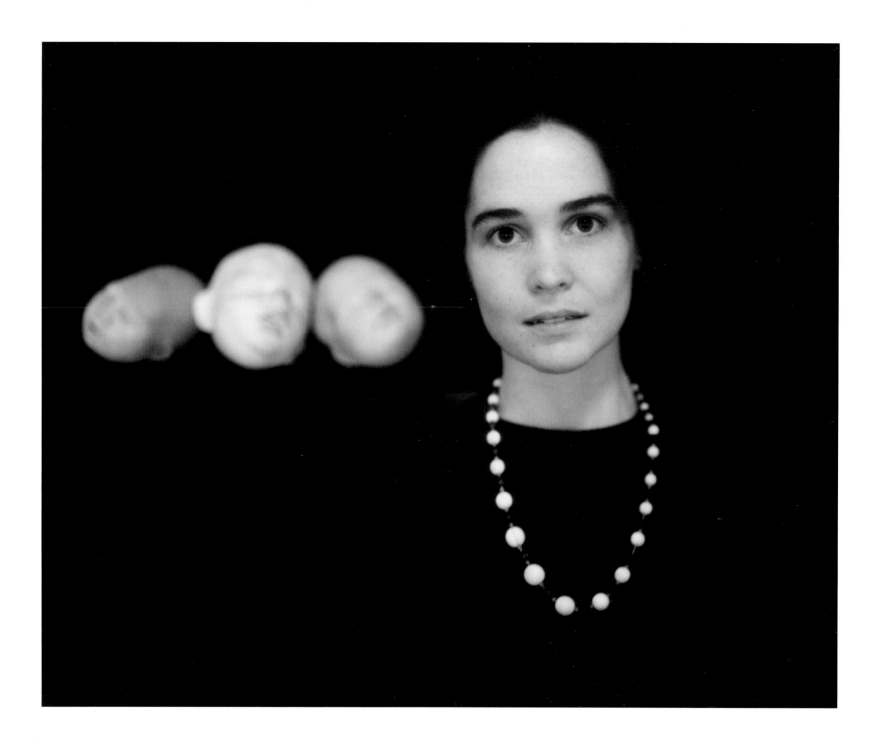

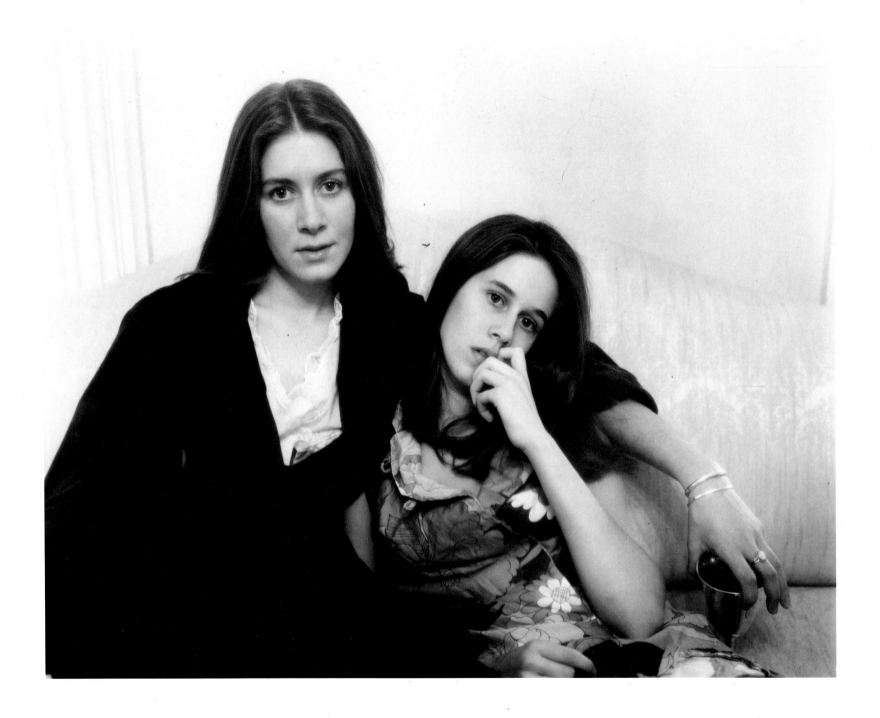

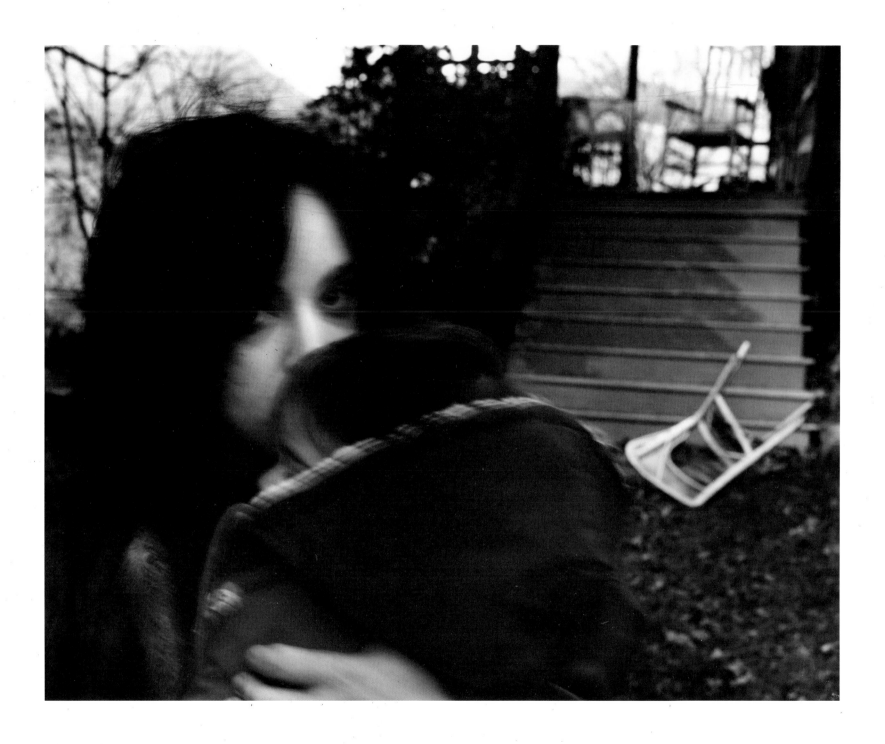

PLATINUM PRINTS

1978–1980

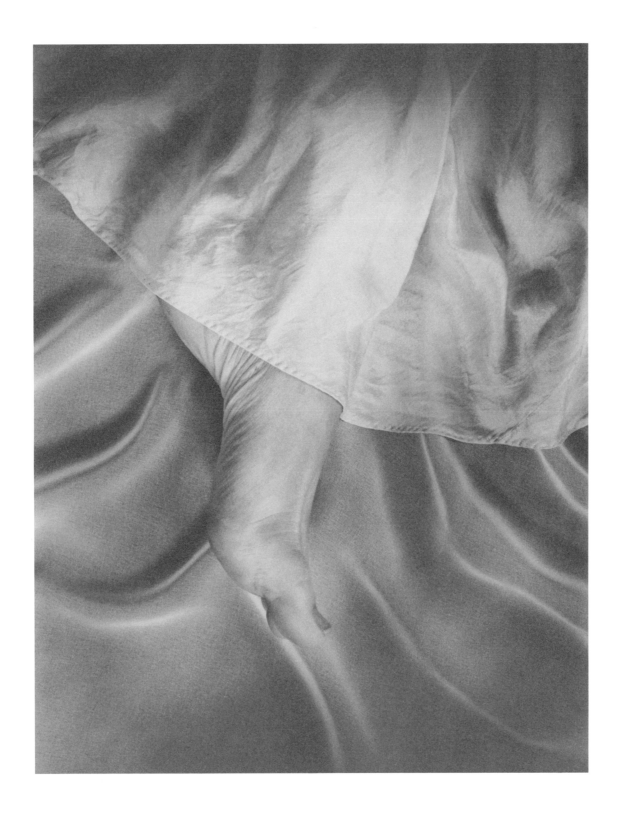

33

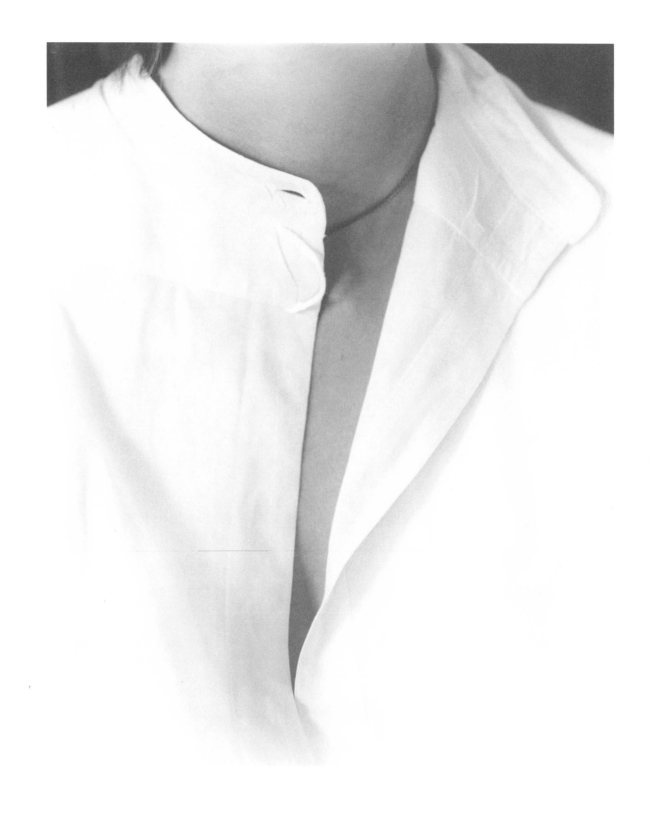

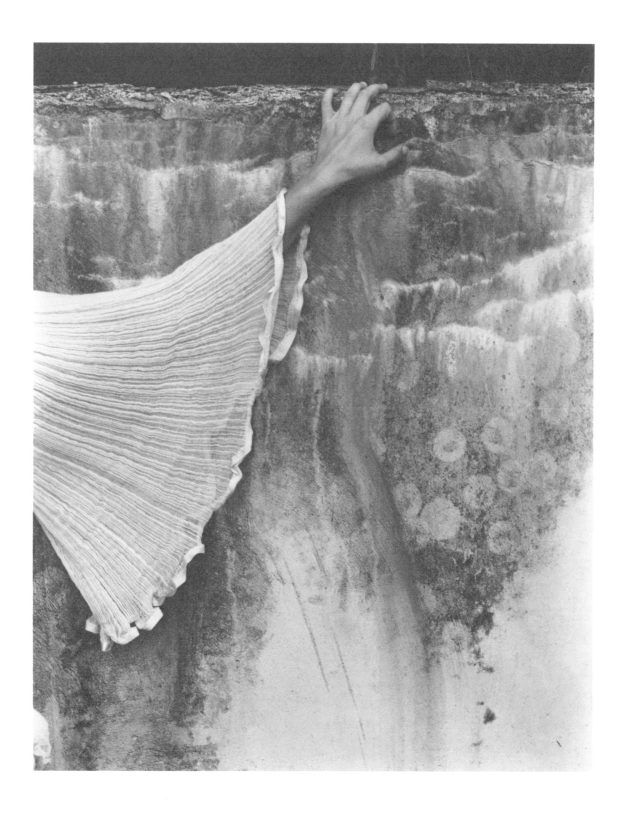

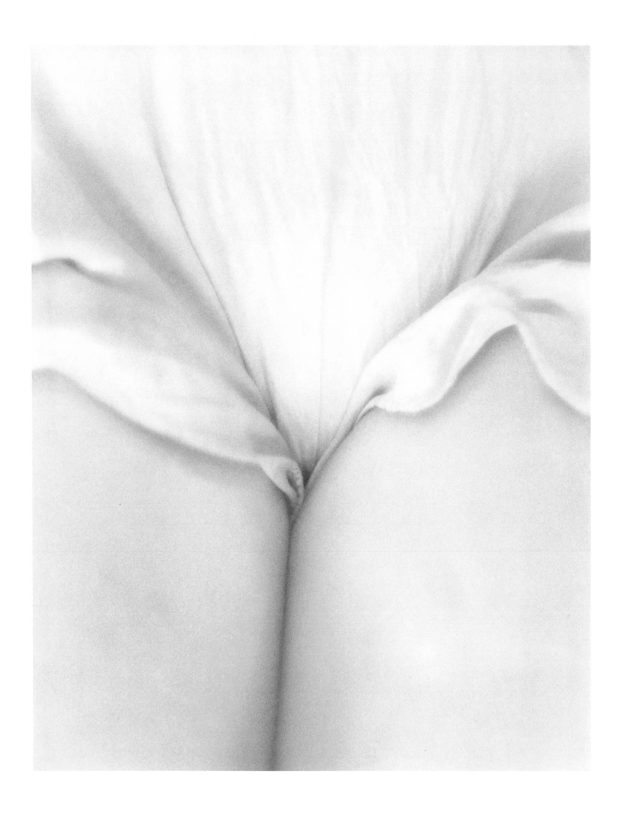

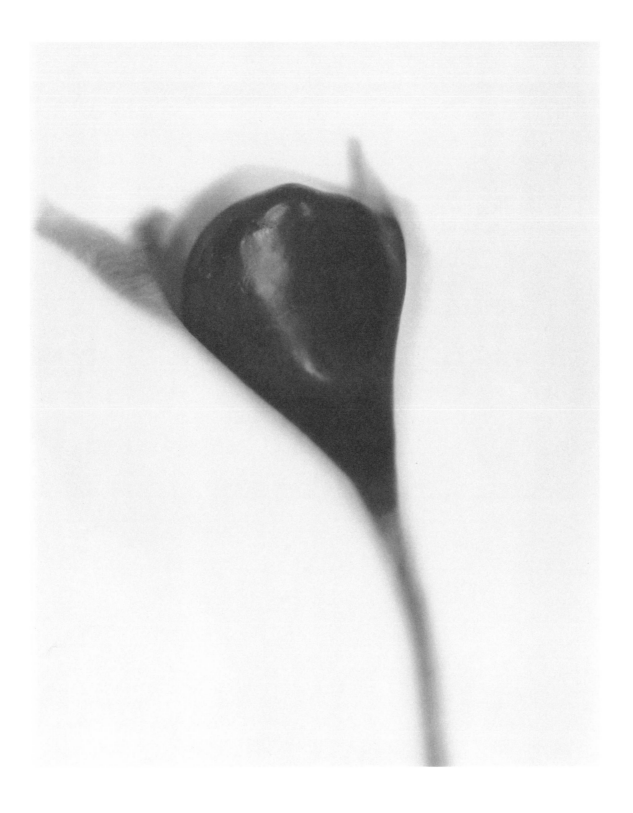

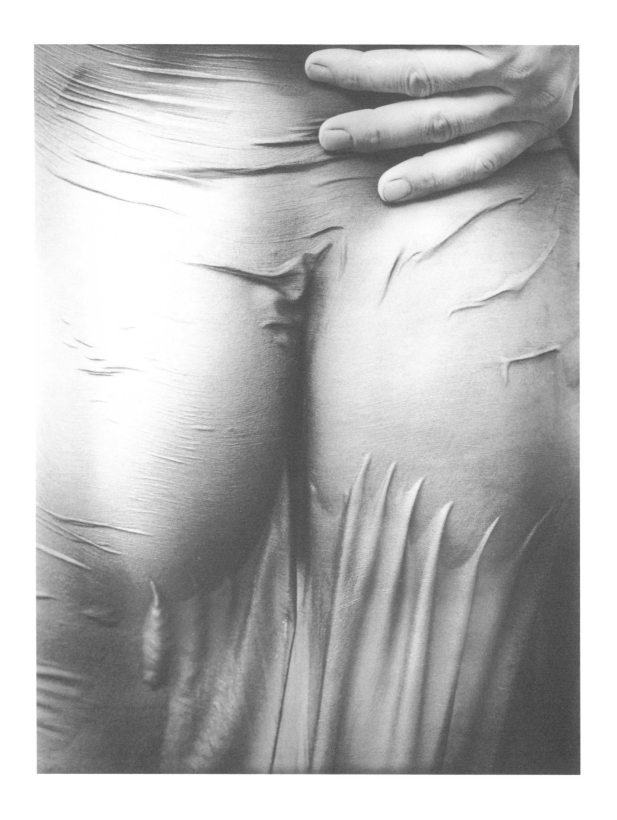

38

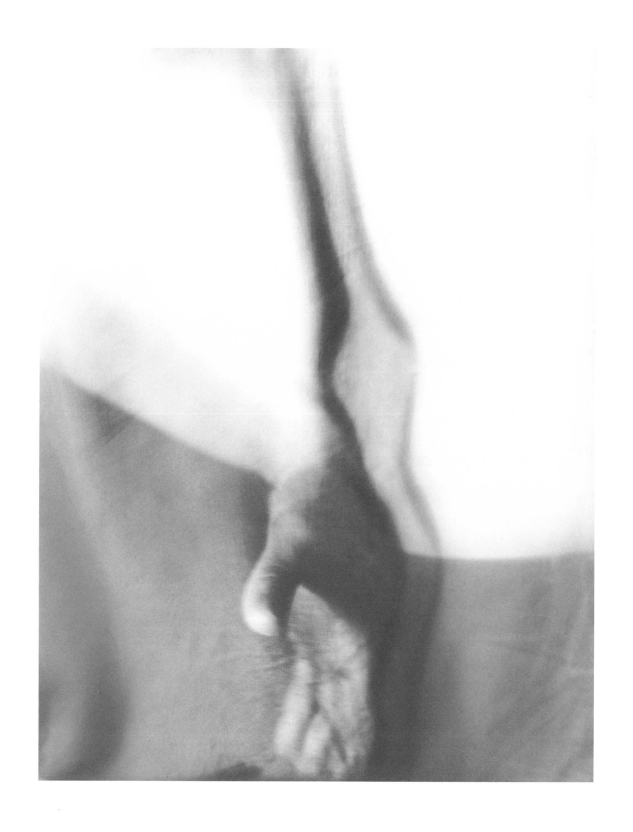

39

CIBACHROMES

1981–1983

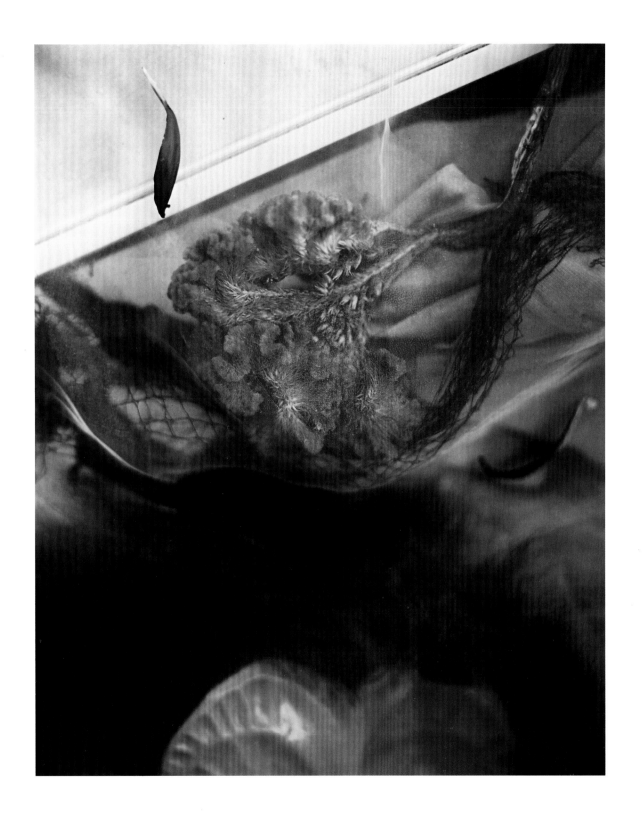

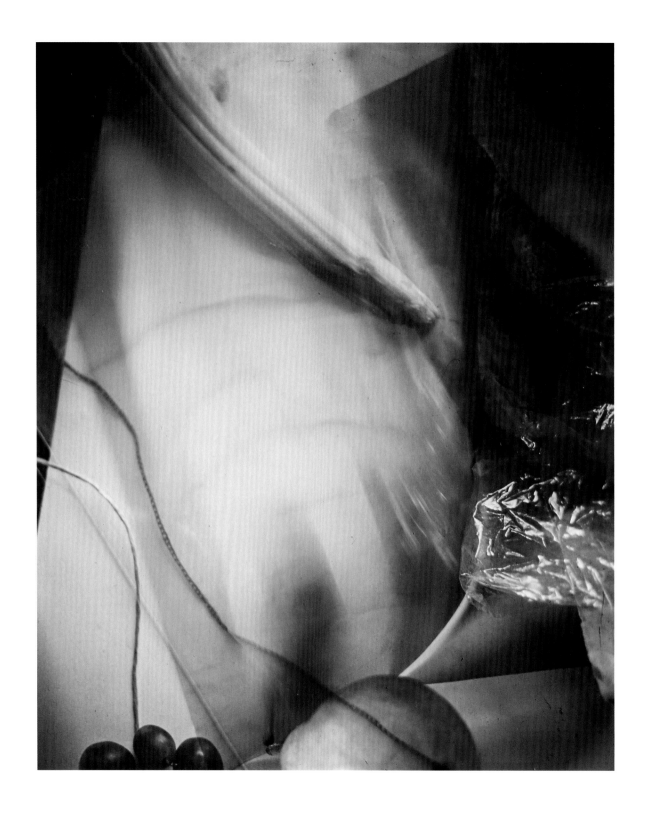

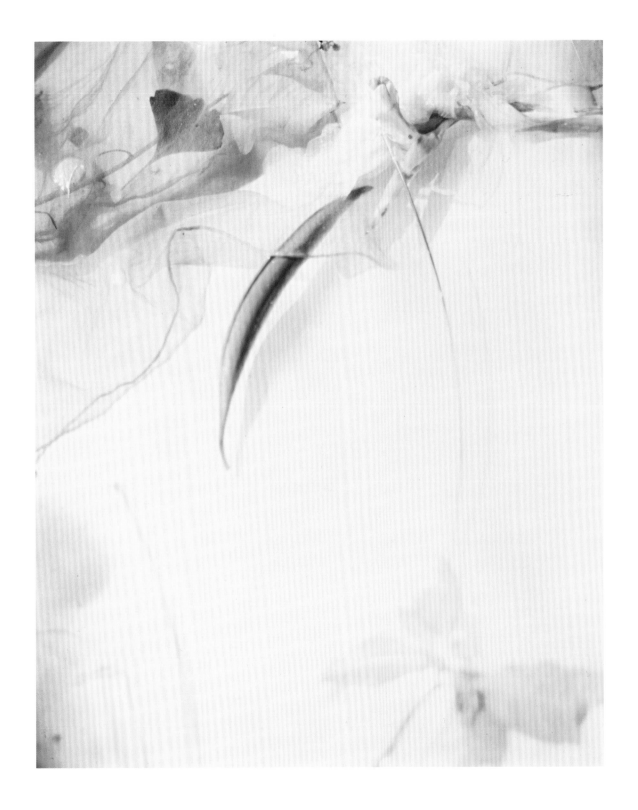

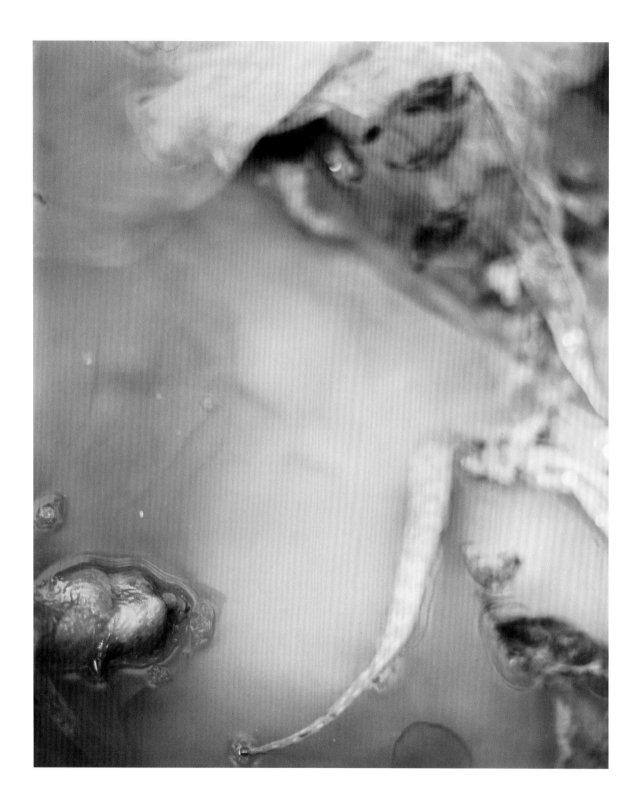

8 x 10 Polaroids

1983

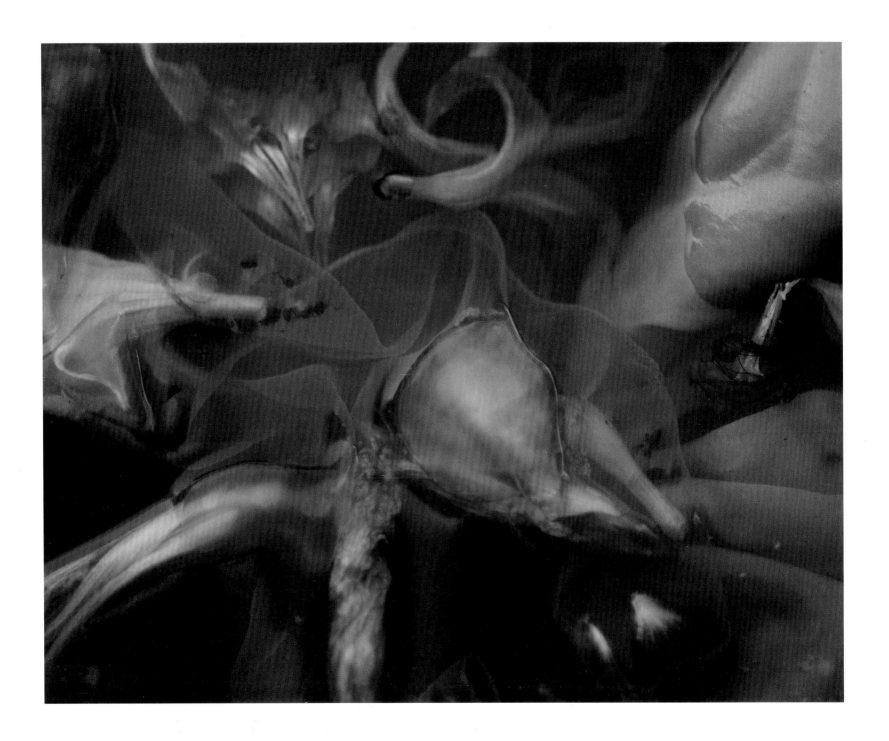

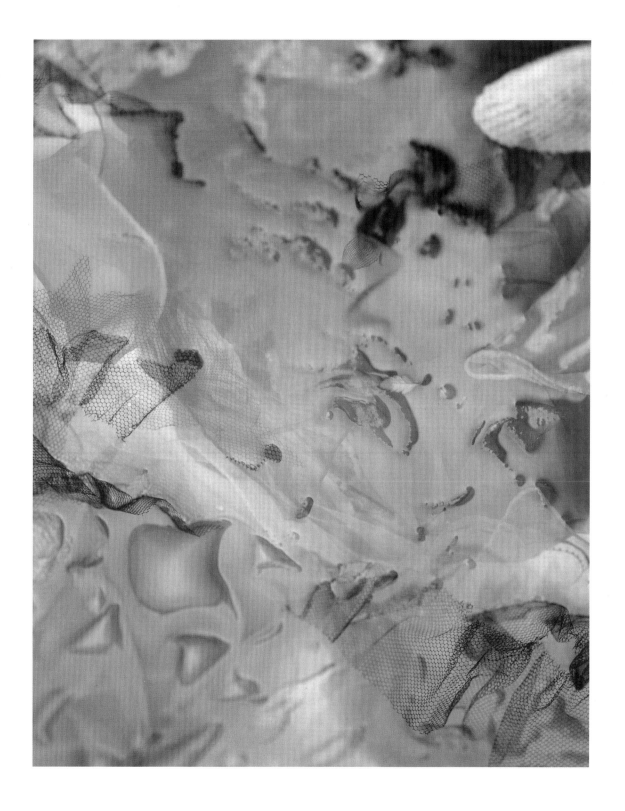

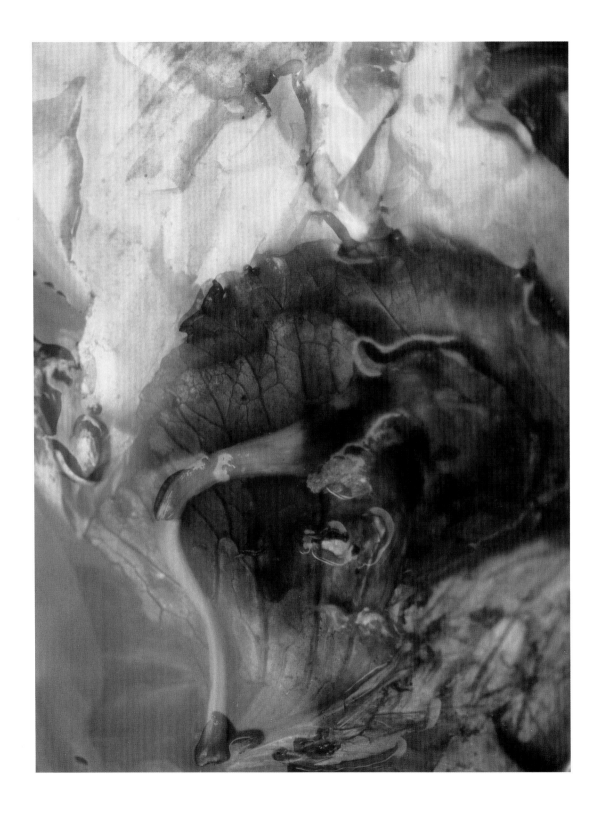

48

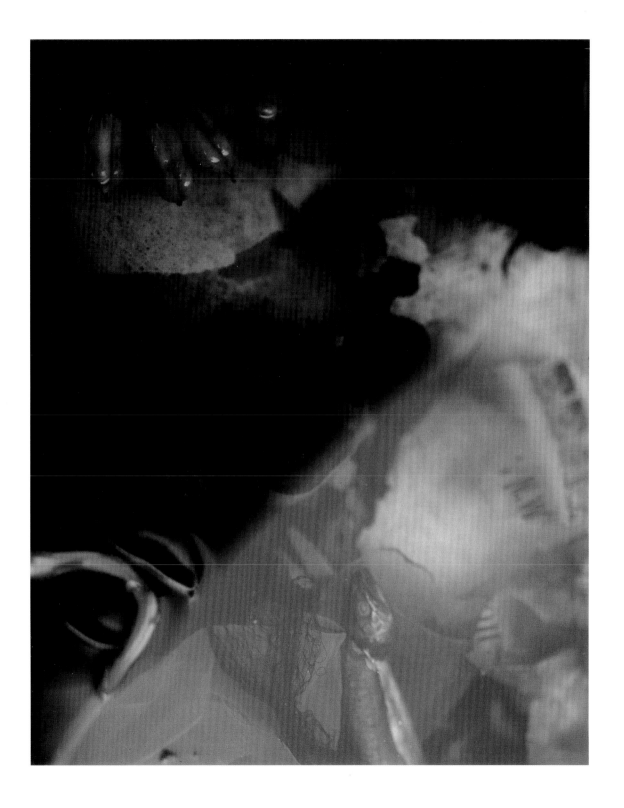

20 x 24 POLAROIDS

1984

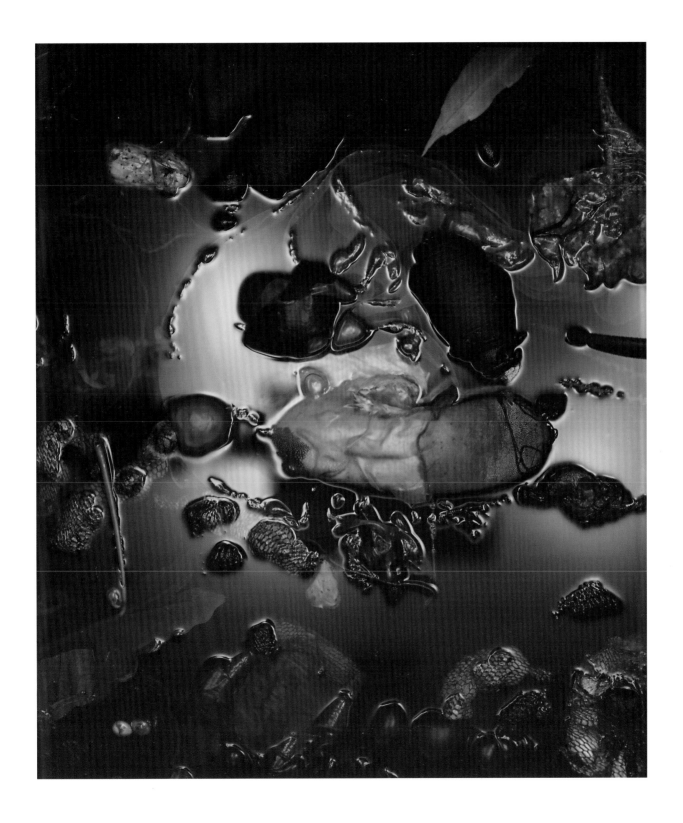

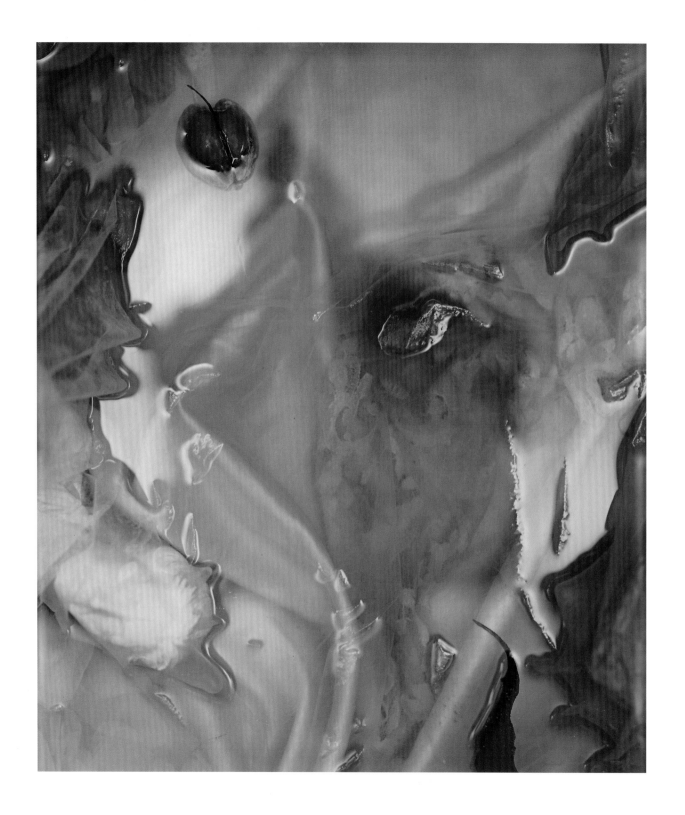

From

AT TWELVE

1983–1985

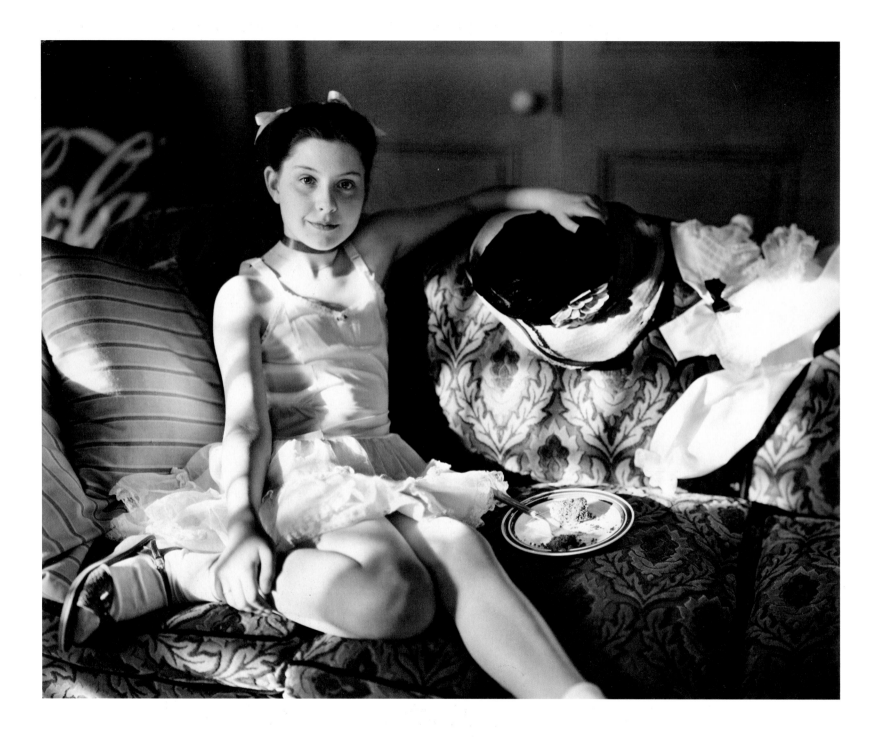

54

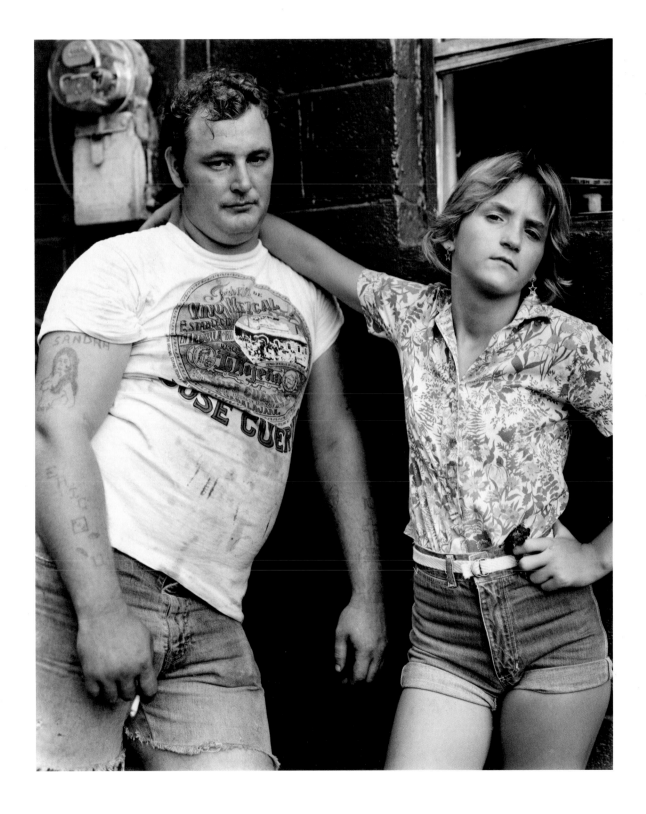

55

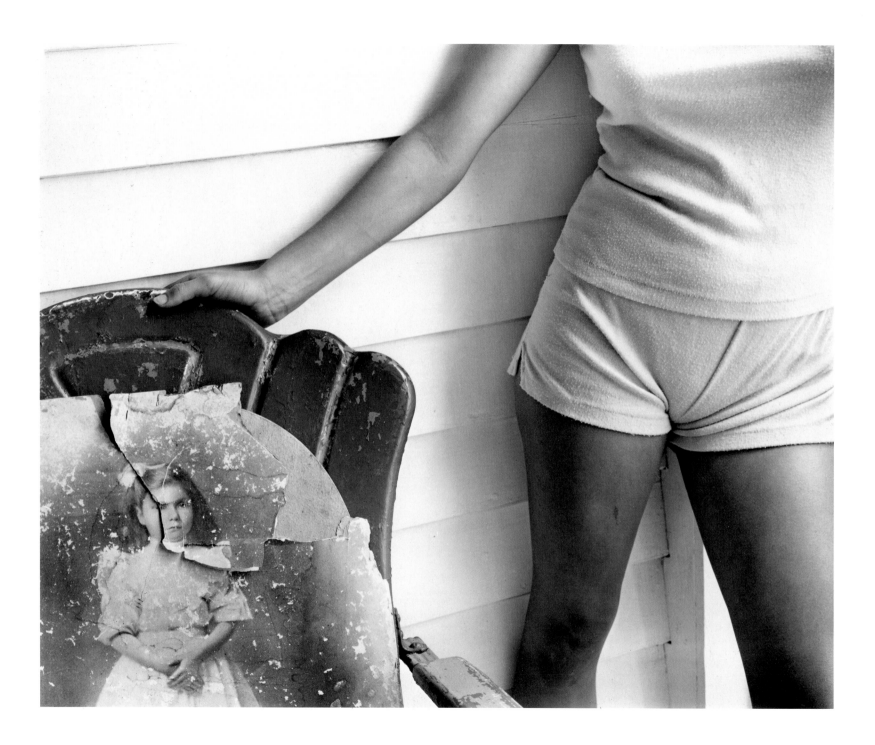

56

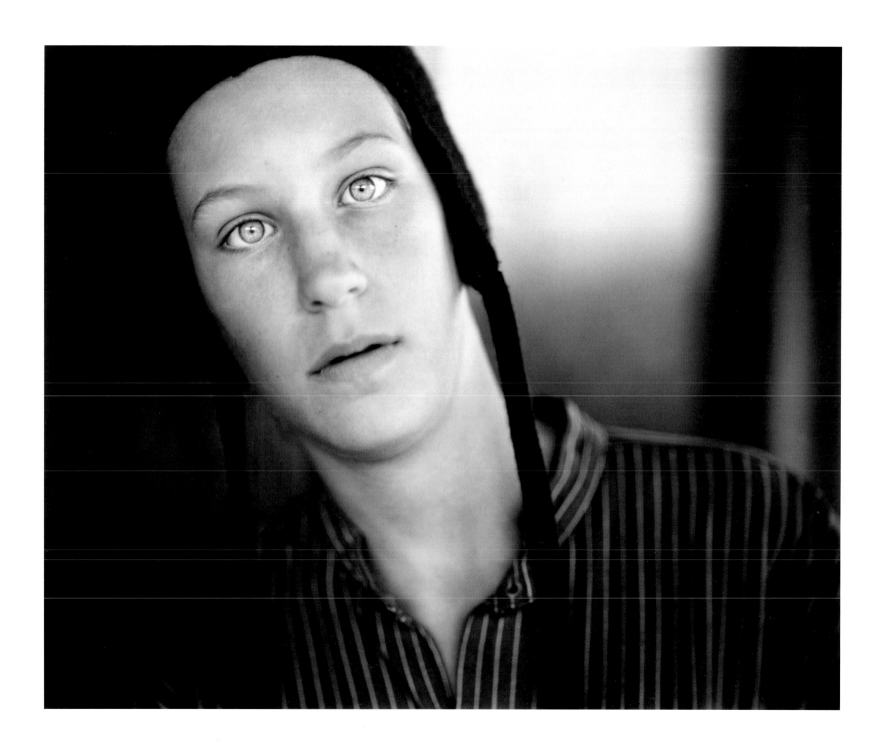

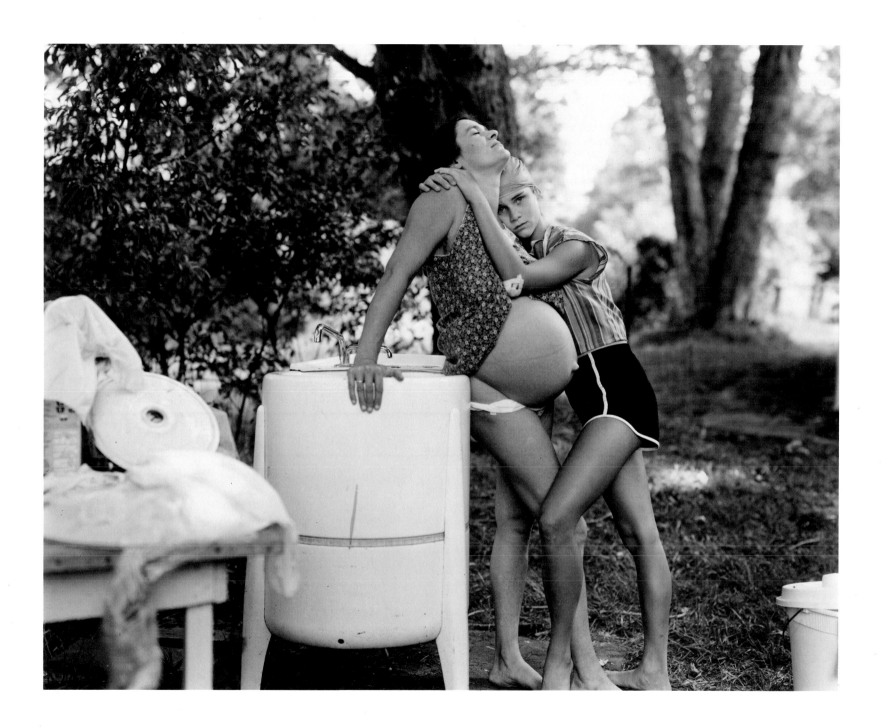

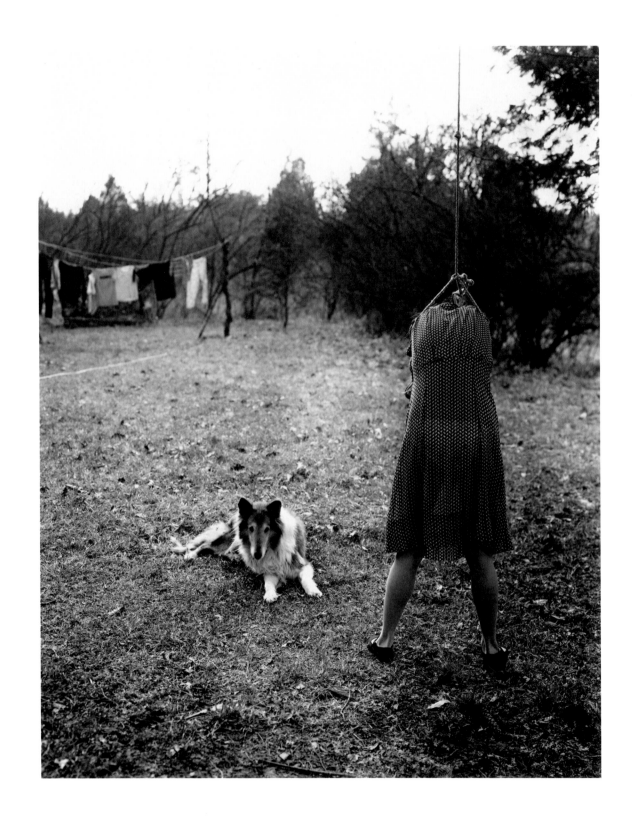

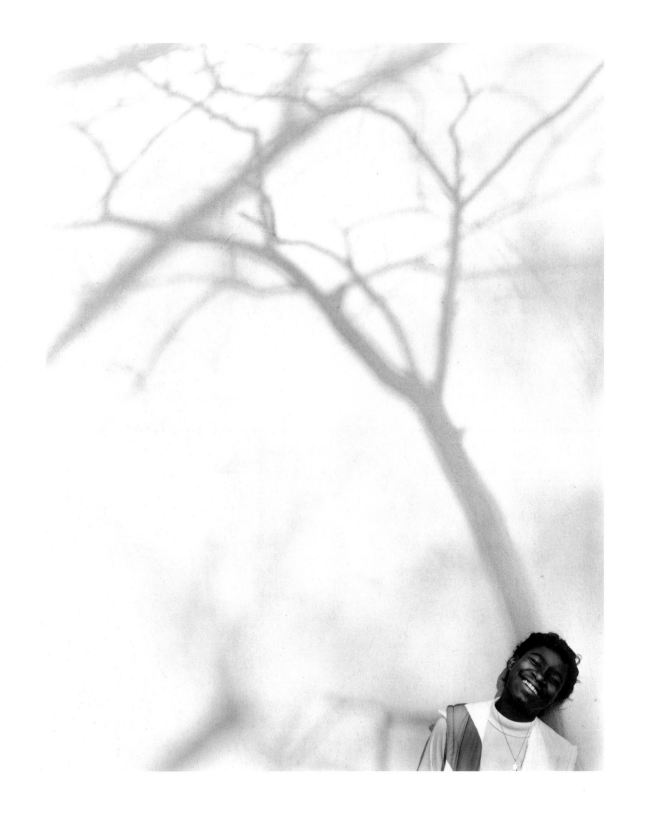

From

IMMEDIATE FAMILY

1984–1991

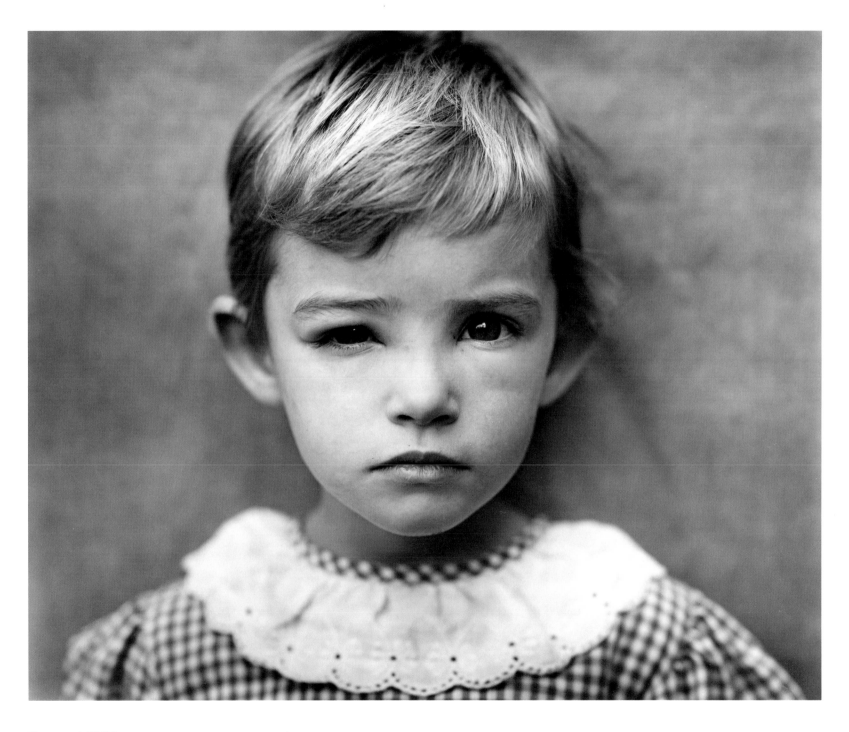

Damaged Child

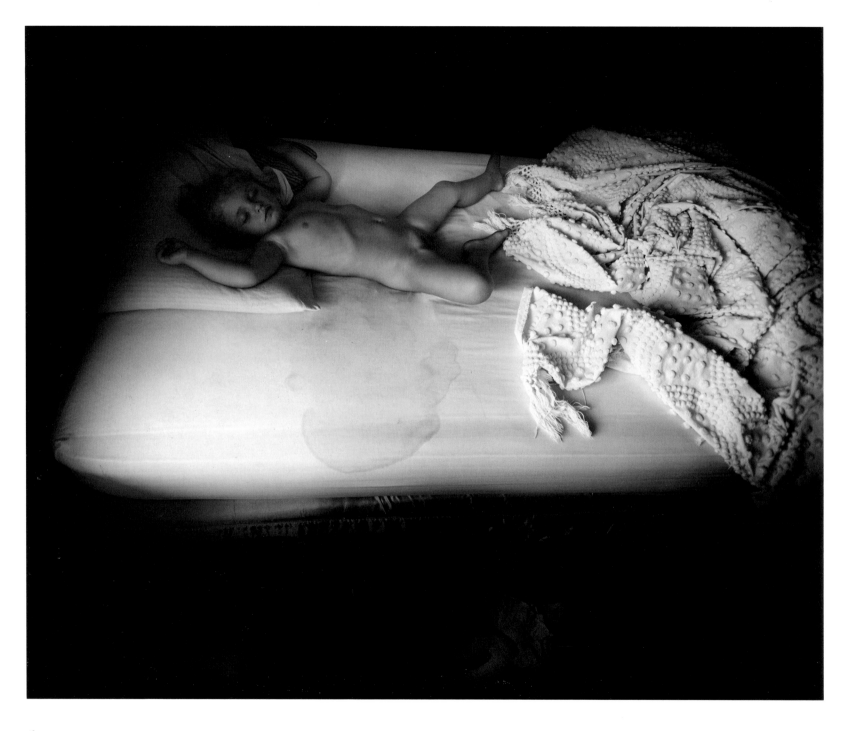

The Wet Bed

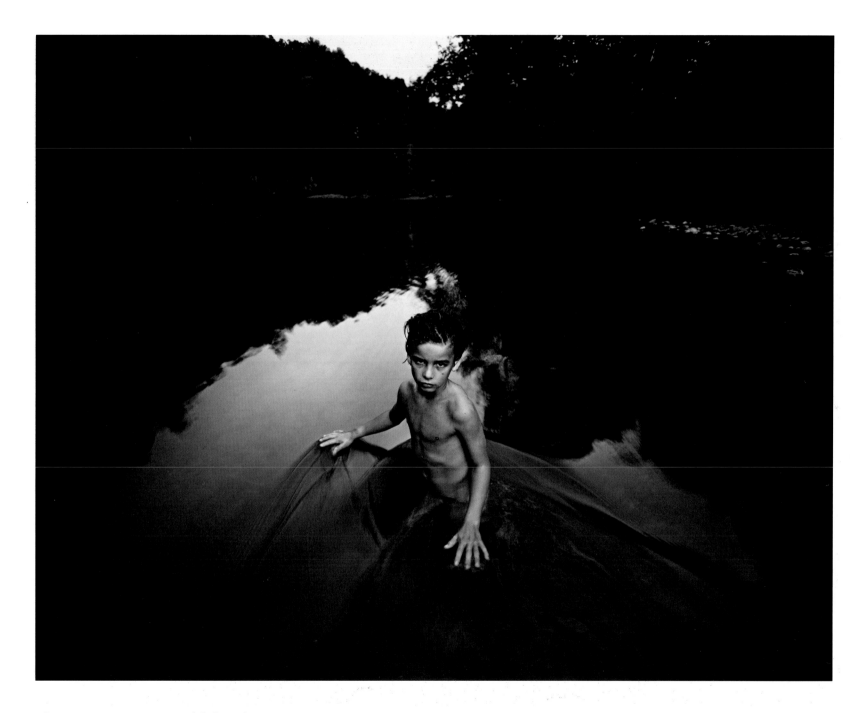

The Last Time Emmett Modeled Nude

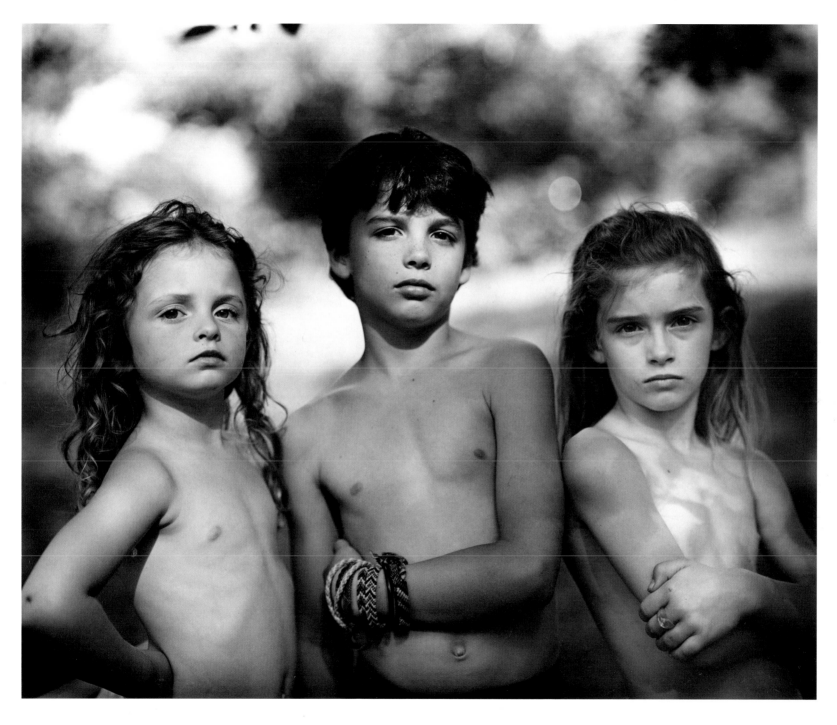

Emmett, Jessie, and Virginia

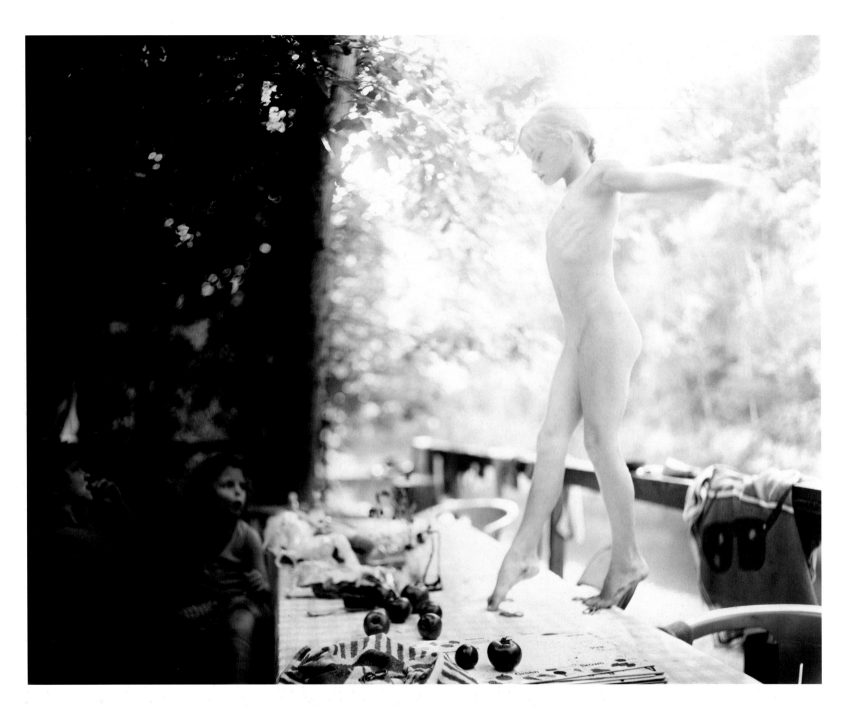

The Perfect Tomato

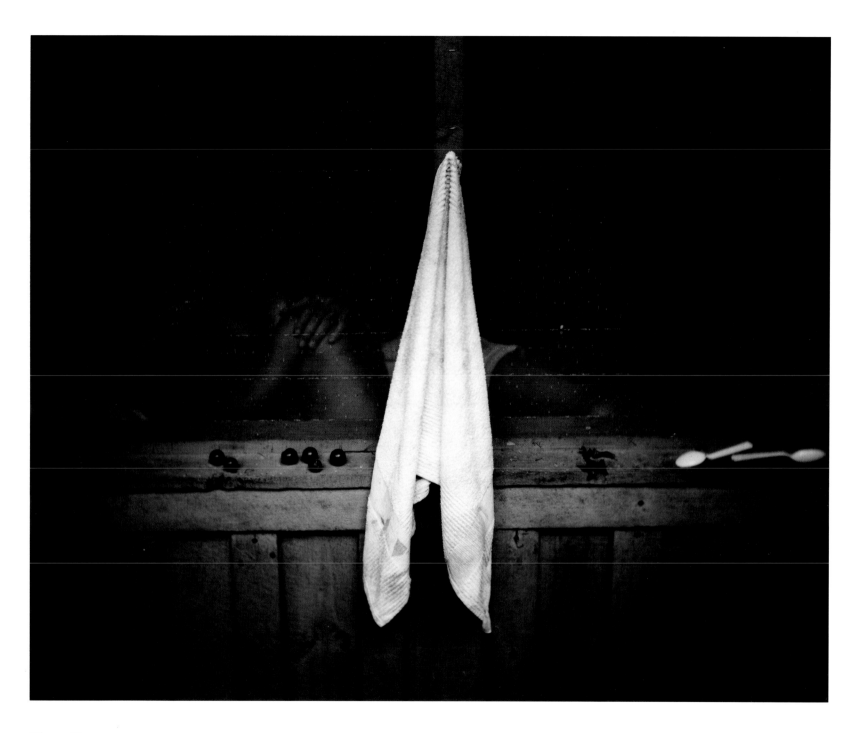

Cherry Tomatoes

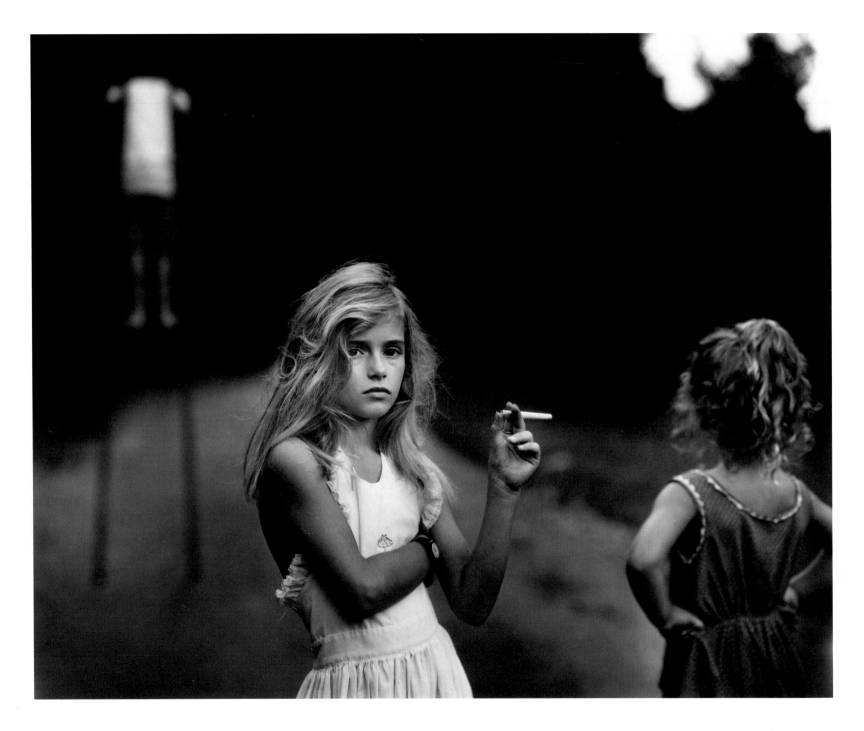

Candy Cigarette

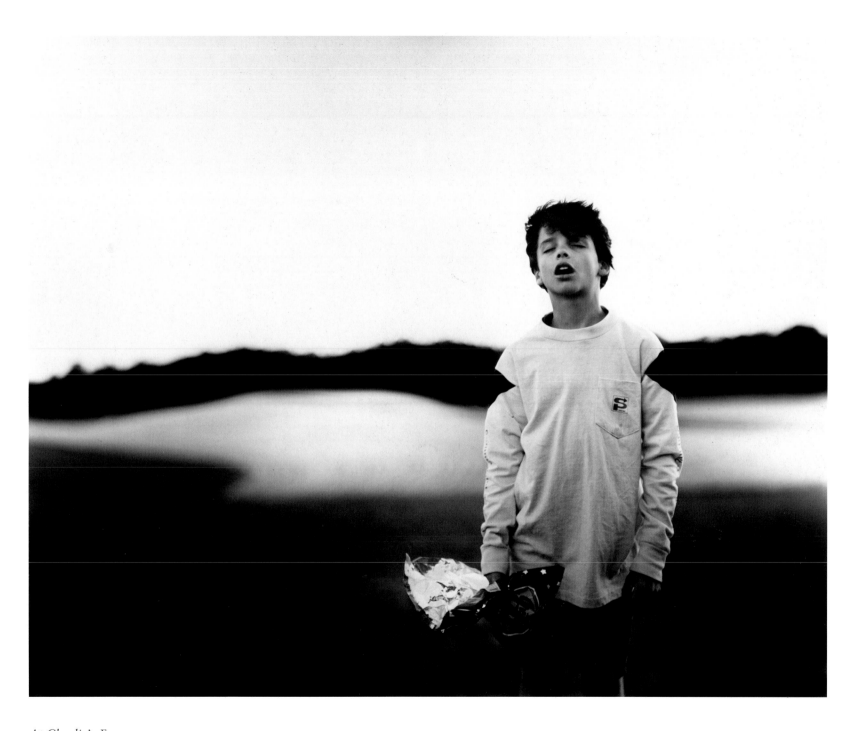

At Charlie's Farm

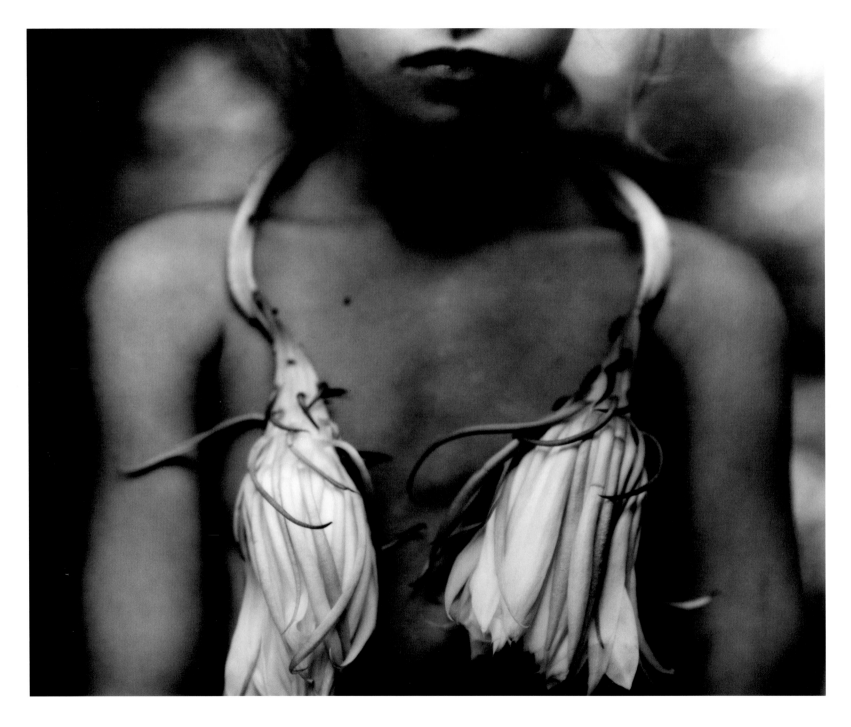

Night-blooming Cereus

FAMILY COLOR

1990–1991

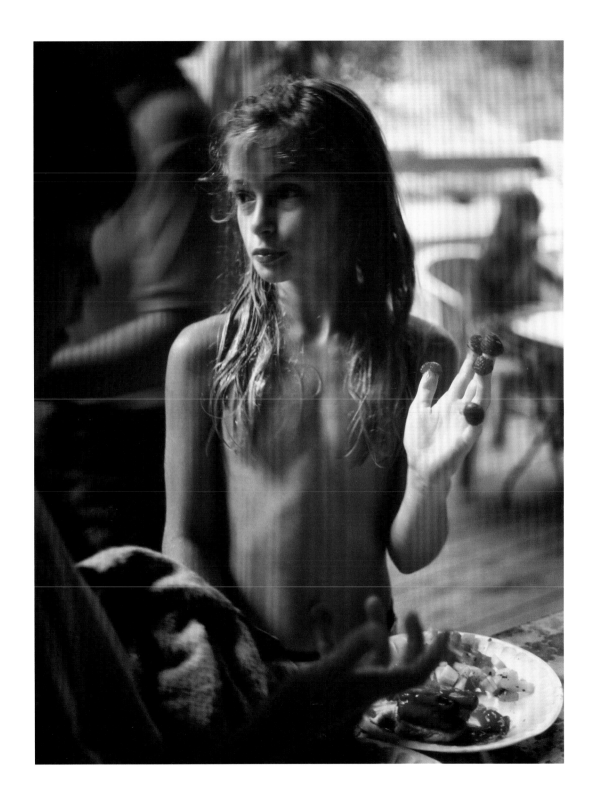

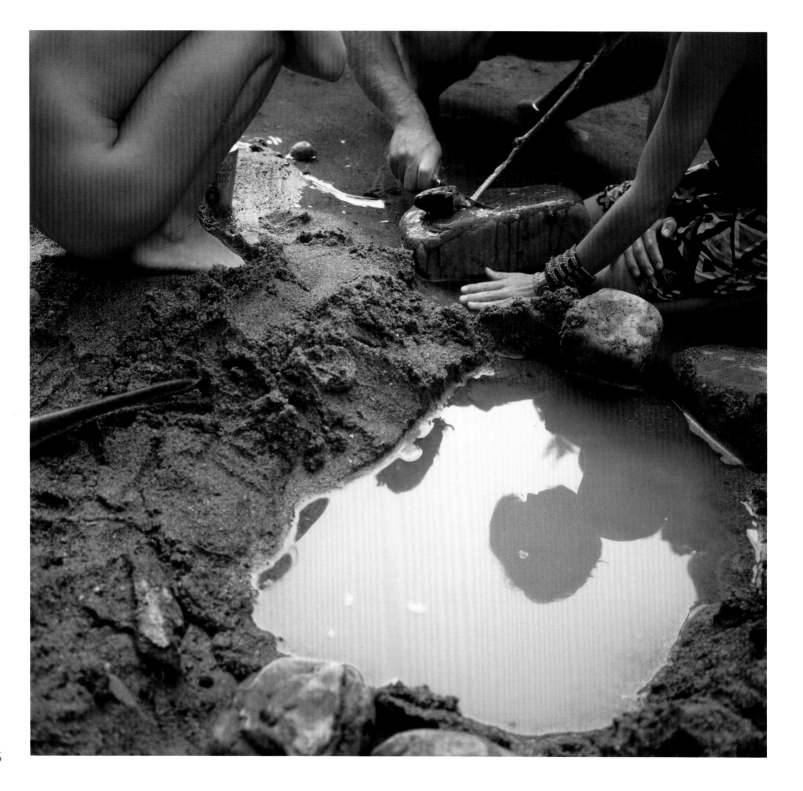

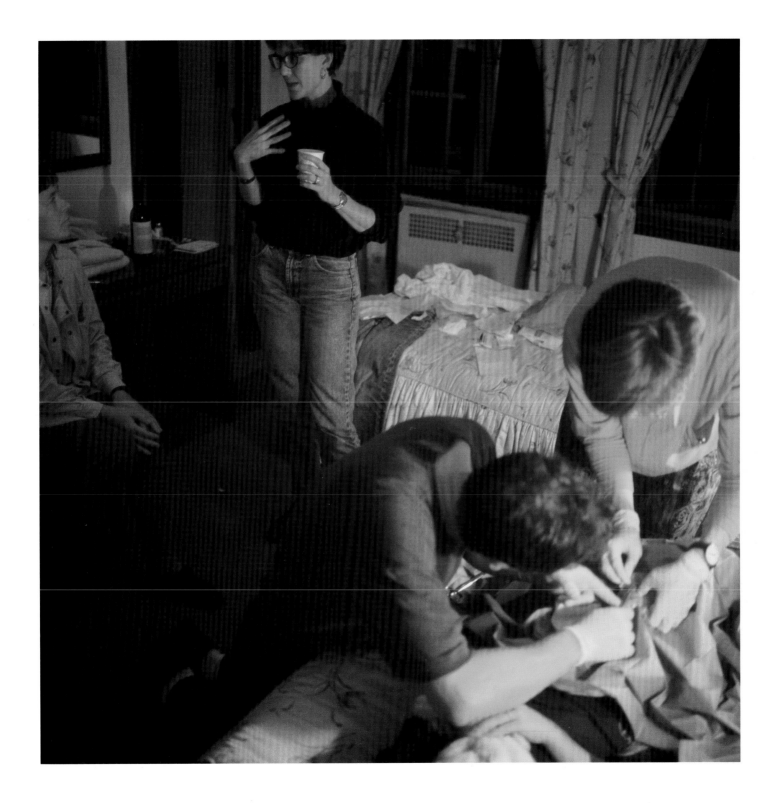

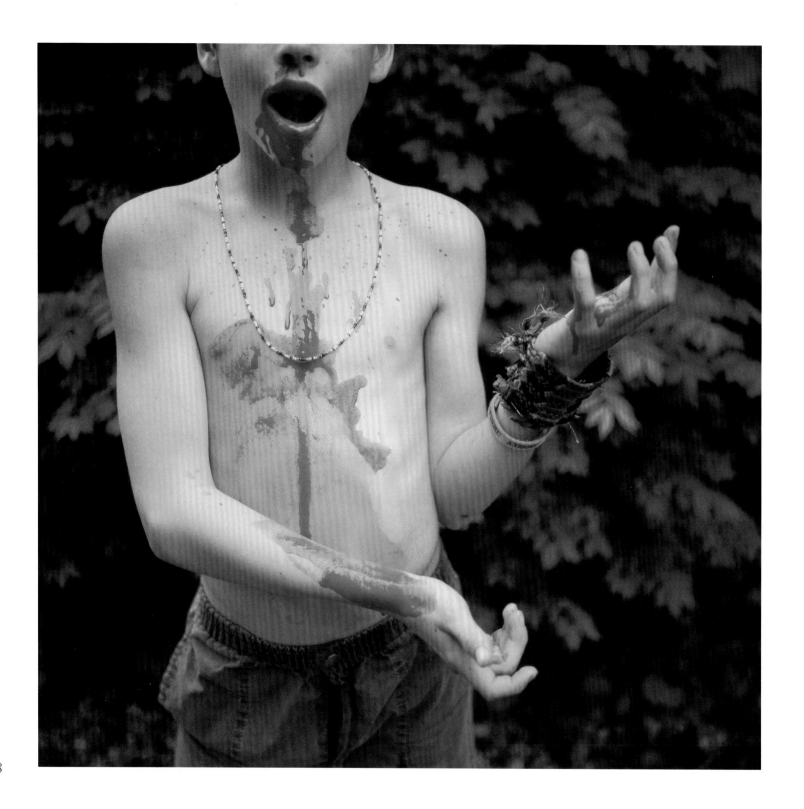

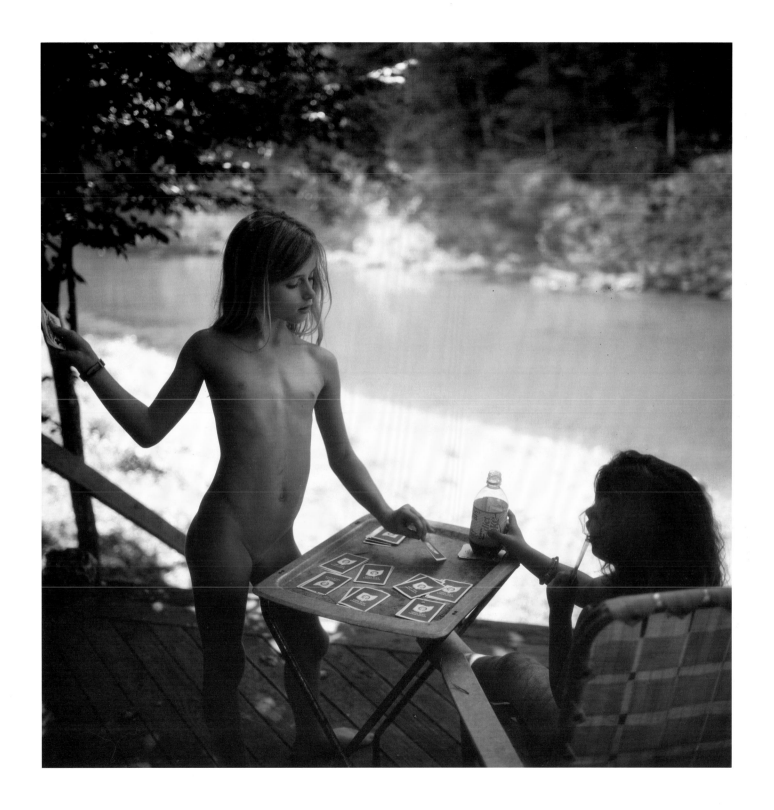

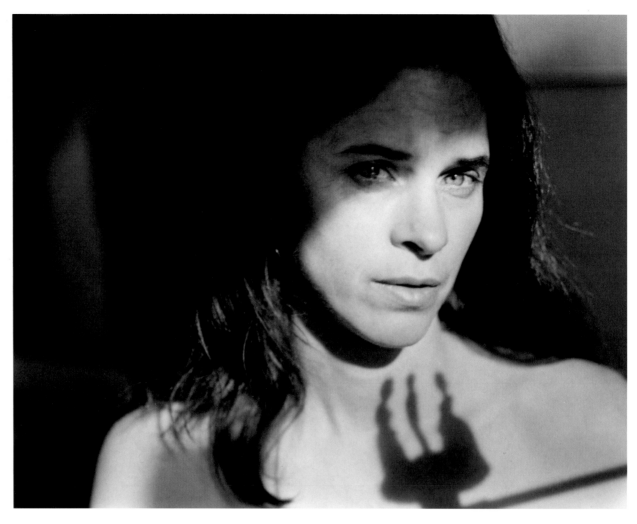

1994

Library of Congress Catalog Card Number: 94-70675
ISBN: 0-89381-593-4

Aperture Foundation publishes a periodical, books, and portfolios of fine photography to communicate with serious photographers and creative people everywhere. A complete catalog is available upon request. Address: 20 East 23rd Street, New York, New York 10010. For orders, call: (800) 939-2323.

First edition 10 9 8 7 6 5 4 3 2 1

Printed and bound by The Stinehour Press, Lunenburg, Vermont
Book design by Dean Bornstein